BROKEN

A Collection of Poetry

Helen Freeman

Illustrated by Margaret Jeeves

AuthorHouse™ UK Ltd.
500 Avebury Boulevard
Central Milton Keynes, MK9 2BE
www.authorhouse.co.uk
Phone: 08001974150

First published by AuthorHouse 05/05/2011

ISBN: 978-1-4567-7690-9

This book is printed on acid-free paper.

authorHOUSE®

The Sculptor

The good sculptor knows
what to remove, what to leave.
True shape emerges.

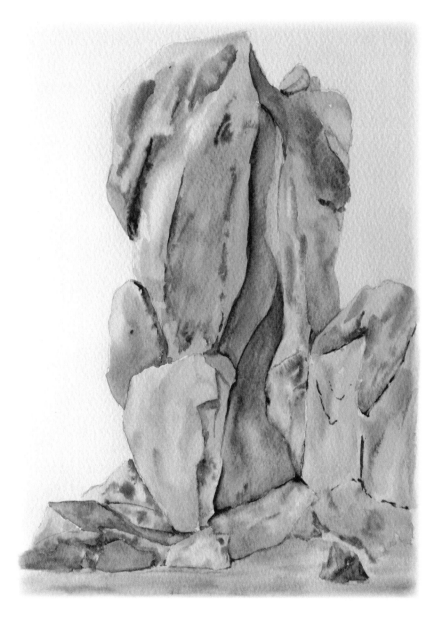

This collection of poems is dedicated to my amazing family
for their love, care and support,
and to the medical personnel who have helped in my recovery.

The Last Morning I wish I'd had....

It started so well.
Birdsong.
Coffee, a quiet time.
I did ten laps of the pool,
took a shower
and flossed my teeth carefully.
I picked out matching underwear
and dressed, admiring
my new dark red nails,
polished and shining,
no cuticles in sight.
Woke kids. Bright breakfast
with laughter and love.
Put on the slow cooker for our
evening meal and even
had time to clean
my back kitchen cupboards,
job pending since I don't know when.

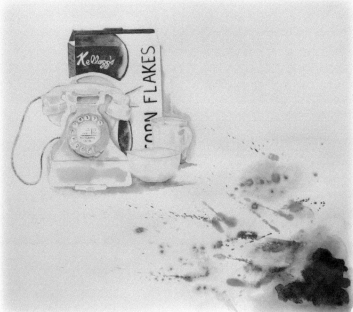

I logged on, read the news,
tidied up the inbox,
deleted all the junk mail and
fired off some quick replies.
I gathered together my lesson plans,
anticipating an eager response from my students.

After a lingering farewell with my husband at the door,
I set out along the highway to work.

3 Seconds

In 3 seconds, you can strike a match and light a fire,
make a great catch,
batten down a hatch.

In 3 seconds, you can gulp down a glass of water
or a wee dram, if you've got the stomach for it,
you can say, "I love you,"
to your daughter.

3 seconds is how long it takes
to send that sneaky text when the teacher isn't looking.

In 3 seconds, you can catch and pass a netball
before the whistle blows,
you can identify a birdcall or a footfall,
you can unpack a small holdall,
you can almost eat a meatball.

You can name a song from a 3 second sound clip,
you can pick a tulip or do a back flip,
you can tie up your sarong,
you can sense right from wrong.

In 3 seconds you can be smashed into oblivion.
In 3 seconds you can change almost beyond recognition.

Words Electric

We are your servants
following every nuance:
the flick of your wrist,
an eyelid flutter,
a barely perceptible head twist.
We jump at just the
right moment and pace,
whispering, nudging, colouring.
Sometimes surprising you,
round mouthed,
sometimes smashing you open
like a draining coconut,
screaming alongside.
We are not bald and formulaic.
We are not cold.
We have flavour and bite:
a subtle hint,
a bit of a kick,
a knock-out punch
pounding straight in
like a thundering rhinoceros.
We fly, we flow, we glow,
tumbling and triggering,
exploding,
instant or slow release.
Unveil us
to reveal
a perplexing allure,
rousing, inspiring, intriguing;
an inflammatory
copper-cabled
electric shock
charging through.

The Door

Voices above me,
"You don't know where you are, do you darling?"
You're here, but where?
I fade, dizzy and lost
submerging
gone.

That blurred buzz again.
What's happening to me?
Fog, half-coloured, indistinct
crackling off-track. Hello, where are you?
Anyone there?
I'm trying to tune in
to grasp something
a bar, a line
gone.

Pain-saturated
I can't move.
Stretched and pinned
like one of your butterflies.
Buoyant on a blow-up lifeboat
drifting in the wreckage of poly-trauma,
a blanked out take.
I'm the lead part
but completely unaware,
shot without me

propelling me through a doorway
I never chose,
opening at the foot of an overwhelming cliff.

I fade, dizzy, but moving on...

Coma Punctuation

coma slumped in sleeplike state
cloistered pared down trickling
closure threatening
full stop

cant you give an extra m
comma preferable please
content with semi colon
a pause

there must be other lines
enjambment tumb
ling out vitality
flowing

Mirror, Mirror

Mirror, mirror,
way up high,
what I see might make me cry.
In the lift above my bed,
glimpse my face,
it looks so red.
Mirror, mirror,
won't you lie,
airbrush me, quickly, try.

Mirror, mirror,
can't be true,
huge and swollen, green and blue
colours painted on my nose.
Limbs all bandaged,
ghostly pose.
Mirror, mirror,
lie to me,
show me what I used to see.

Morphine

It seeped in.
It sped down the corridors.
It spread through the pain.
It sprang into the system.
It saturated the brain.
It rolled in the imagination.
It modified the senses.
It made the mind blurry.
It strayed round the fences.
It painted new scenes.
It pictured the invisible.
It chatted with nobody,

and then it left,
cloaked in confusion,
red-faced and miserable.

Hanging In The Balance

'Alert and conscious'
according to A & E notes,
yet unconscious of everything.
Floating,
unhinged,
unmoored,
knocked to oblivion,
floored.
Speaking without deliberation,
no concentration,
no communication;
thoughts absent,
replies unregistered.
Eyes open, looking
but retina-blanked.
Pain, so intense,
full tanked,
feeling nothing at all.
Hanging in the balance,
days vanish,
a plugged-in puff.

ICU

Late at night,
 machines buzzing,
 a noisy ward
 sleepless again,
ICU

Commotion,
 nurses rushing,
 new arrival
 right next to me,
ICU

Lift, pump, push,
 medics crowding.
 Will he make it?
 I don't think so,
ICU

Room empties,
 choked and crying.
 "Focus on me,"
 your soft whisper,
"I see you."

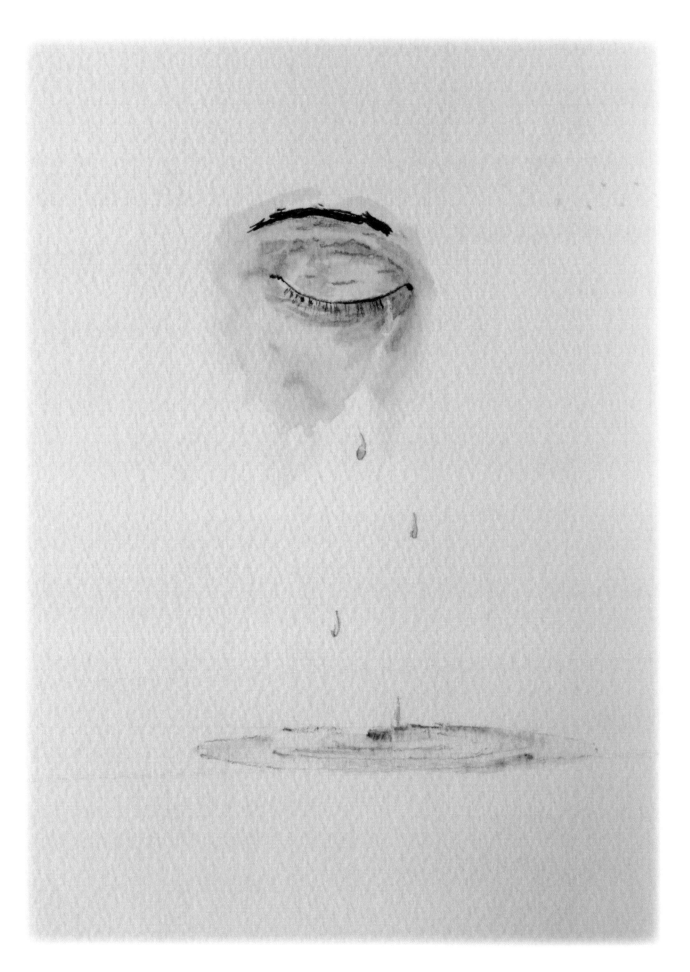

I'd Rather Be

Needled to life support,
monitors rumbling,
confined near the door of death,
intensive care,
intubation,
chained and gasping for breath.

Outside two birds
are building their nest
of twigs. I've watched them all day.
With only one nurse ,
and a solitary window,
I want a visitor who'll stay.

Reminded you're with me,
knowing it all,
this day is better with you,
intensive care,
communication,
relieved that we'll make it through.

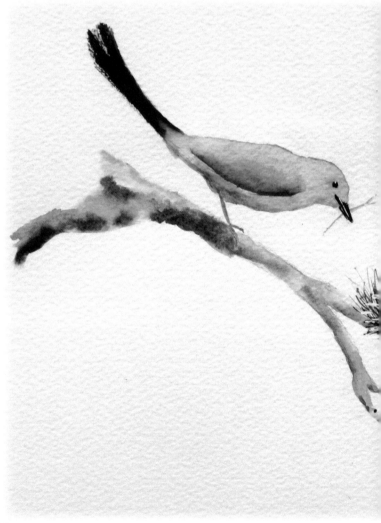

Eyes on a Sparrow

Out on the broken wall
or beaking oddments
off scorched sand
for your complex,
you work diligently,
from thorn bush
to dried out cactus
and round the rim
of putrid sump,
where veiled housemaids
in floppy nightgowns
lug overflowing black rubbish bags
and leave yesterday's pilau
for the strays.

I saw you at noon, hopping
on a dust-laden ledge
blending in with the desert,
the call to prayer reverberating.

I tracked you all day from my isolation bed,
I heard your evening crescendo
from the belly of the scan
heartening my melancholy.
I missed you when you vanished from view.

I'm saving pine nuts for you.

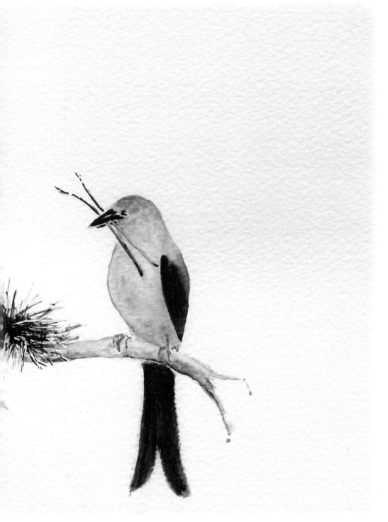

Turn The Screw

I feel it in my bones
I feel it is my turn
Turn in the spotlight
Turn on the table
Table of tools
Table of blood
Blood spilling out
Blood added in
In with the drill
In with the saw
Saw anesthetic drip
Saw nothing at all
All chiseled open
All wired and bruised
Bruised and blue
Bruised from impact
Impact so forceful
Impact splitting seconds
Seconds blitzing
Seconds shattering
Shattering the air
Shattering news
News to be spread
News to be prayed over
Over to you
Over to my will
Will I lose heart
Will I win
Win in my mind
Win in my muscles
Muscles atrophied
Muscles must tighten
Tighten the bolt
Tighten the screw
Screw up
Screw loosen
Loosen
Up

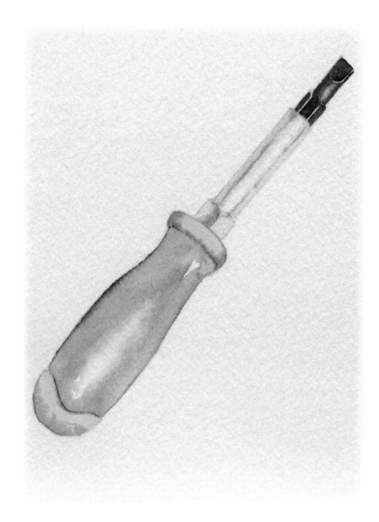

Disabled

Parakeets keel and dive,
wheeling from tree roosts
out into the fuchsia sky
where the fading sun
glints off streamlined
green flashes,
glider planes
twirling round
like balloons in a breeze
tinting the desert.

Suddenly caught and confined,
ecstatic freedom behind;
vistas of limitless scope
exchanged for a coop, and hope
flies off in retreat,
while wings sag, heavy
and day darkens,
straining to stretch,
disabled.

A Sturdy Stranger

Popping grapes
into his mouth
beside my misaligned limbs,
he beams assurance;

tangible,
by his manner of talking;
two detailed minutes worth,
ripe with history,
fresh, brimful of hope.

Lifted up,
I know he too has been
through a pounding,
a crushing prediction:
"You'll never walk again."

I watch him
stride out and shoot
a pip into the bin.

Isolation Island

Her eyes scrape open to a crescendo
of sobbing in her neighbour's room again,
an amputee missing more than her arm.

For a second, she contemplates walking
in to encourage calm, never mind her
own need for a decent night's sleep, but then,

wincing, she remembers there's no going
anywhere. Searching for the red button
to summon someone, she discovers it

hanging just out of reach, like Hades grapes.
Resigned to wakefulness, she decides on
Lady Gaga, at least to drown the flood

of noise. Fumbling, with clumsy plastered hands
and an ache in her contagious torso,
she knocks the iPod to the floor. Breakfast

is hours, tomorrows away, made longer
by the wait for masked reluctance to
convey the tray to her infected side.

Cabin fever knots her stomach. She stares
up at the stained ceiling snaking patterns.
Wall-climbing, immobile, every limb cast.

Hospital Presents

Don't throw away the flowers,
you have to take them home,
they're not allowed in this ward,
there's only room for a brush and comb.

Please take away the chocolates,
I don't mean to be so rude,
and all those sticky toffees,
they don't fit down my tube.

I can't hold your heavy novels,
my body needs to rest,
a prayer, a hug, a gentle touch,
your presence is the best.

The Prize Haircut

"Forgive this indignity,"
I wished you had said.

You picked up the scissors
and carelessly sheared
right down to the scalp.

Can't you see how I'm feeling,
drugged up to the eyes,
joining dots, catching flies,
slabbed out under neon,
with all these bones broken?

But your cut takes the prize.

Wish list

I wish the night nurses would stop chatting. That
I was not the one tubed and stuck to this bed.
That tonight was a full moon and a canvas
deckchair, my soft red pashmina and not one
broken bone. That I could erase statistics,
raise the highway divides and rebuild this place
out of brand new quadriceps and green mountain
breezes, a cartwheel-starred sky and the amber
musk fragrance of an Abyssinian rose.

Why?

Meant to happen?
Maktoub, written by the hand of God
maybe.

He knows everything.

Punishment?
For headstrong and contrary ways
maybe.

I certainly deserve it.

A gift?
Given to bring growth and change
maybe.

On the lifelong journey.

Random?
Accidental chance
maybe.

Could happen to you.

Attacked?
A target of evil
maybe.

We have adversaries.

Victim?
Of careless mistaken action
maybe.

Consequences of folly.

Still valued?
Worth protecting from death
surely.

'Why' fades to 'How' as I go into tomorrow.

Aspects Of You

Date grower
Seed sower
Mother adorer
Coffee pourer
Scent wearer
Secret sharer
Opposition floorer
Goal scorer
Text number giver
Good time liver
Chick wower
Knee bower
God fearer
Mood cheerer
Oud strummer
Tabla drummer
Meat eater
Nose greeter
Lesson skiver
Crazy driver
Brow stroker
Rib poker
Hand holder
Thought moulder

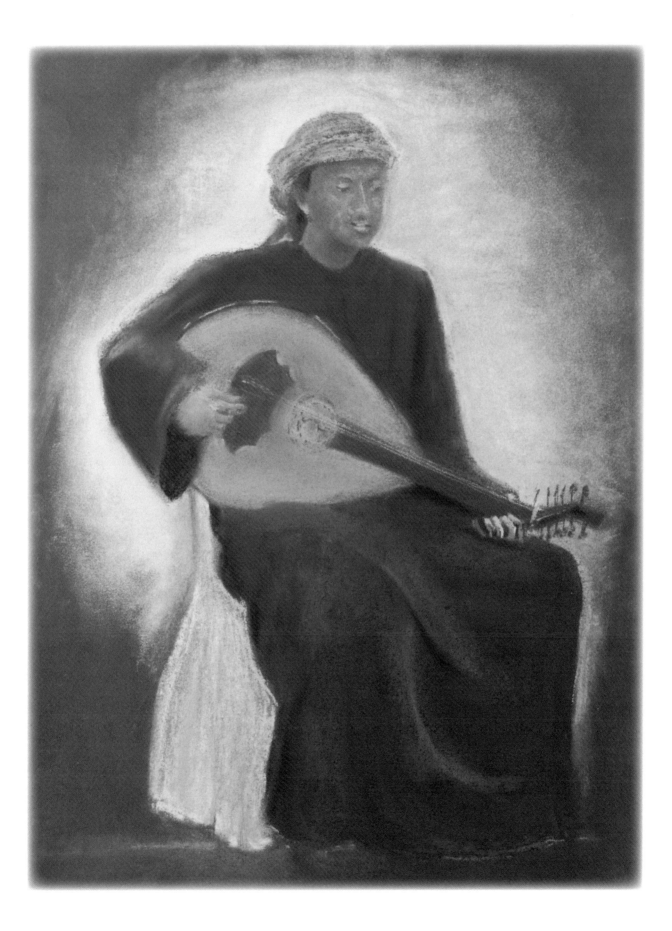

A Whisper

Though the walls press in around me
and I cannot move a limb,
though the visitors have left now
and the hours wheel slowly by,
though antiseptic gloves
draw down the scraping blind,
though there are no flowers in the vase
nor a discharge date in sight,

yet I will savour the whisper in my spirit,

My Shoga (Good Friend)

She came to pray that I wouldn't die,
as the sun sank down in the eastern sky.

Muezzin voices echoed out,
warm winds fluttered her veil about.

She sailed in, smiling, although her dark eyes
shone with tears she tried to disguise;

red desert dust clinging to her shoes,
"Well," she asked, "Are you better? What news?"

She gently greeted peace upon me,
guttural blessings surrounding warmly.

She pulled out gifts from her flowing gown,
hints of frankincense on skin so brown,

black patterned henna flowering into rings,
flashes of gold glinting under her wings.

I saw the effort she had made,
to see me here. Her hair had greyed

from loss and hardship. She mentioned the daughter
she'd buried last month, twelve other children, her

vast offspring, the husband she'd nursed ten
years ago, who'd forgotten her name, When

tears puddled down, authentic, raw,
I saw blind acceptance in every pore.

She served up fragrant coconut rice,
seafood, coffee, and then kissed me thrice.

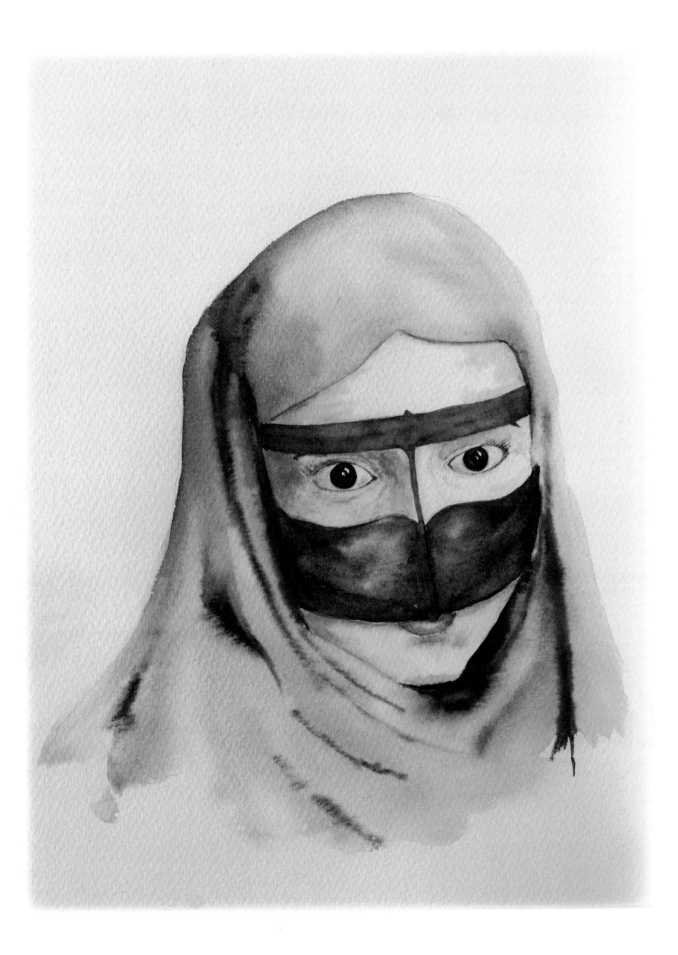

A Lament For My Neighbour

I moved into your ward, Badriya,
your bed stood next to mine,
just two bones smashed when your car crashed,
we all thought you'd be fine.
So many guests from near and far
surrounded you each day.
Seemed so happy, dates and coffee,
incense settled to stay.

Badriya so sweet and young,
Badriya who wants to have fun,
Badriya with flowing hair
and a musical teddy bear.

Your broken shoulder surgery
passed by, neat as a stitch.
Your back hurts now, we don't know how,
it looks like there's a hitch.
We thought you'd walk today, Badriya,
but your legs seem paralysed.
The whispered prayers, the anxious stares
veil fear, thinly disguised.

Your ample Mum on constant watch,
nervously counting her beads.
Kids home alone, left with the phone,
she tends to all your needs.
The doctors gather round, Badriya,
to check and prick and prod.
"Too bad, too late, this is your fate,
dealt out by the hand of God."

"Where can we take her?" your mother sighed,
"She'll never walk again."
Those hopes and dreams, unravelling seams
that cause the tears of men.
Oh gentle neighbour, so forlorn,
the world keeps spinning on.
My prayers for you will not be few
now that old ways have gone.

Badriya so sweet and young,
Badriya who wants to have fun,
Badriya with flowing hair
and a musical teddy bear.

Motherhood

Motherhood,
elemental hormone,
ferocious pheromone,
bellowing up
from deep in the bone,
stoking me, firing me
to reproduce and protect my own.

Motherhood,
innate longing I've known,
long waiting to be shown,
you took your time
for seeds to be sown.
Finally, joyfully,
you arrived, like a brilliant gemstone.

Motherhood,
no longer monotone,
precious, priceless cologne
through highs and lows,
nose to the grindstone.
Scenting and sweetening,
together through every milestone.

Motherhood,
ravaged by a cyclone,
uprooted and far blown
craving your hugs,
hellish nights alone,
clamouring and clawing
my way back to the family zone.

Motherhood,
like a loud megaphone,
begging me with a moan,
"Hang on to see
your children full-grown.
Missing you, needing you,
it isn't time for death's chaperone.

A Wee Matter

That catheter under my sick bed,
once a day emptied into a pail;
it sloshed all around,
produced such a sound,
the wee of the ward looked like ale.

Those nappies were very uncomfortable,
never dreamt I would wear them once more.
It's very uncool
to be in a pool
then changed by a nurse - what a chore!

Moving on to the stainless steel bedpan,
was quite a gymnastical feat,
a hard and cold rim
with an angle that's grim,
when lying down flat on your sheet.

Sometimes the dear nurse kept me waiting,
I learned how to ring in advance.
When popping one day,
it was quite a display,
I was virtually doing the dance.

False alarms were extremely frustrating,
I felt like a right nincompoop,
bedpan in position,
full anticipation,
the motion got stuck in the loop.

Returning to strength, I could sit up
and shift myself onto a board;
with an almighty heave,
my bed I would leave
to download in commode what was stored.

I always sought someone to help me
and come to my aid when I called;
private moments denied,
so undignified,
cleaning up left me feeling appalled.

So you see what a wonderful moment,
to be in that room on my throne;
no witnesses there
to see me so bare
and not horizontally prone.

Remade

An earthenware pot,
I think I'm okay:
functional, fairly useful,

displaying dried stalks,
sprayed grasses, patio lanterns,
driftwood, whatever,

standing decorated,
coarse and gritty
in a forgotten corner.

Muscled limbs occasionally shove me
behind sofas, doors,
obscured, disregarded.

I remember being chiseled
by skilled, scarred hands.
Not the prize piece

but good enough, I felt.
I wished to be bigger,
smoother, more exotic,

with handles, swirls, whirls.
When I was smashed I thought
you'd sweep me away.

The smell of the glue,
the painstaking process,
pierced hands piecing.

longer.
may stumble, you can't stay here any
ment. Though unlit and you
ate upward move-
Activ-

nearby.
Keep pressures away and gentle friends
steps, beginning right here.
take only small
Try to

you know.
which will carry you much further than
start on this dark journey
up before you
Don't give

Upward

Grace Displayed

I visited Halima while still in my wheelchair,
one blistering summer's day last year.
She answered the door, tottering on her zimmer.

Her cautious walk and feeble frame
contrasted strongly with her vivid eyes
and ready smile, instantly lifting me up,
changing my mood, infectious, gracious.
She carefully tried to avoid
dislodging her colourful scarf,
her hair hidden away under
the patterns and platitudes of ancient wisdom,
a waft of jasmine in the air.

Greetings whispered,
her soft, finely-etched face seemed to relax,
her skin, a faded amber,
the shade of desert dunes in the moonlight.
She lightly stumbled ahead,
leading me in
and folded onto her favourite perch.

Birdlike, she pecked at her doughnut,
shakily sipping diminutive cups of cardamon coffee
with smooth unweathered hands.
Her spacious nightdress, covering, enveloping;
a loose cocoon over painful dislocations,
disorders, and a lifetime of hospitalisation.

I imagined her young and carefree,
laughing in the Zanzibar sun,
dreaming of romantic rescue,
and sensed that part of her remained there.
She showed such concern for my recent injuries.
She called me her hero,
yet my pain, acute, was steadily passing,
while hers roared on:
peaking, slightly ebbing, overflowing.

She chatted, comfortably trilingual,
aware, alert, her skinny wrists, slowly gesticulating,
breakably delicate.
I wanted to hug her and tell her
that her spirit shone.

She rose and walked unsteadily to the door escorting me out.
Her smarting grimace displayed
the reality of weakness,
an awful permanent plague
she acceptingly lived with.
Smiling, she fumbled with her headscarf and waved.

Frodo: I wish the Ring had never come to me, I wish none of this had ever happened.

Gandalf: So do all who live to see such times. But that is not for them to decide. What you have to decide is what to do with the time given to you.

The Lord Of The Rings J R R Tolkien

That Wall

To hug my knees close
to my chest once again,
to leap up the stairs
two by two, turn and then
slide down the banisters
and land in a heap,
whirl out to the pool
to bomb-drop down deep.

To race back the tide
up the sun-sparkling shore,
to ride in the wind
and feel the world roar,
to drive down the highway
no flinching at all.
My dreams prod me gently,
keep climbing that wall.

The Coffee Maker

Rahma brewed coffee
in a stately curved pot,
ancient Omani silver.
Stirring the grounds
over a steady flame
she enthused,
"Try tafarteesh herbs
for strengthening your bones,
add pure Yemeni honey.
Drink black squid ink,
eat fresh Barka chicken."
She boiled and bubbled,
added aromatic cardamom
with a pearl handled spoon,
poured through a strainer
purifying, scenting the air
and presented me with a tiny cup.
She sampled a stoned date,
delectable, succulent, ripe,
the traditional accompaniment,
as she sipped and intoned,
"God give you health."
Our husbands returned.
She scrambled to re-veil,
eyes smiling the promise
of tomorrow's fix.

Meetings

Her patched-up hands stiffen, gripping
the steering wheel, petitioning.

She wonders which scorch marks pocking
the road got there from her tyres.

Everyday he roars down that road.
Striving, self-conscious, he races

his mates in an effort to be
better, better than them, better

than all his brothers and cousins.
He needs to stand out from the crowd.

Turning a corner he replays
the collision. Split seconds of

tangling metal, splintering glass,
screeching smoking smash. He winces,

relieved. He had climbed out scratchless,
while her blood had pooled around him,

her hands shaking, but not with his,
there, but absent, an empty stare.

He'd stood in the dock, embarrassed,
guilty, his brothers looking down.

Hot-cheeked, he remembers the pale
broken woman, mowed down, wheel-chaired.

Their eyes had met.

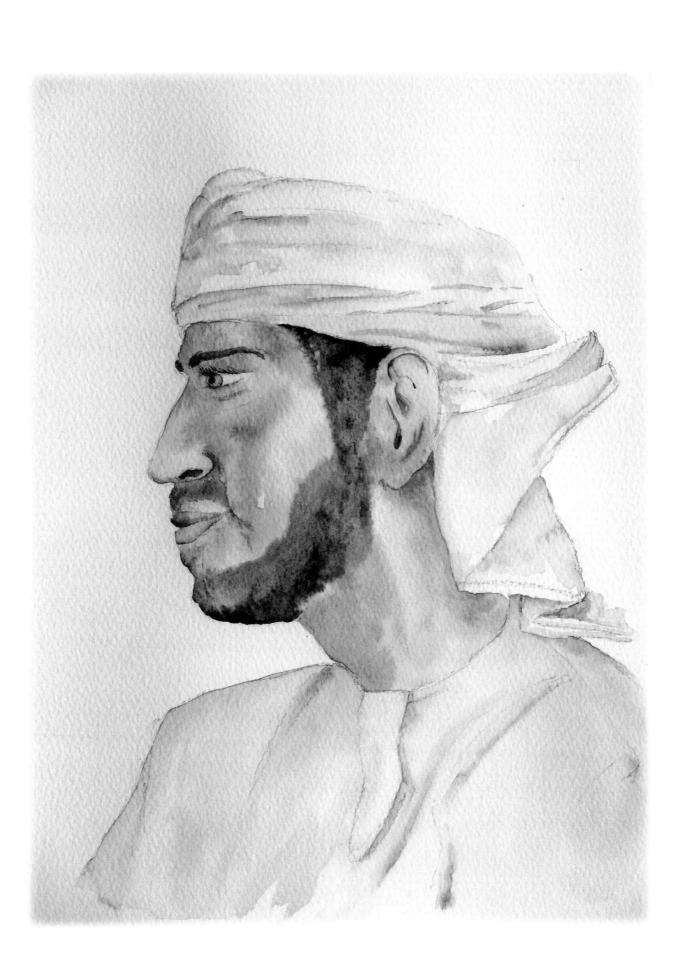

Nostalgia

Because one morning my orchid unpacked
settling itself into the room,
I slid off my bed and onto the wheelchair,
manoeuvered gingerly towards
memories stored in a musty chest,
blinking awake from protracted sleep.
Time to wander back that distance
and see just what we have become
and how Mombasa Roots are after all this time
and whether I'm really African still
and when were my legs that long and shapely?
And if my thoughts were too sentimental
and where were you when I won the high jump?

The Statue of Nike, Winged Victory of Samothrace,
2nd Century BC marble sculpture, Louvre Museum, Paris

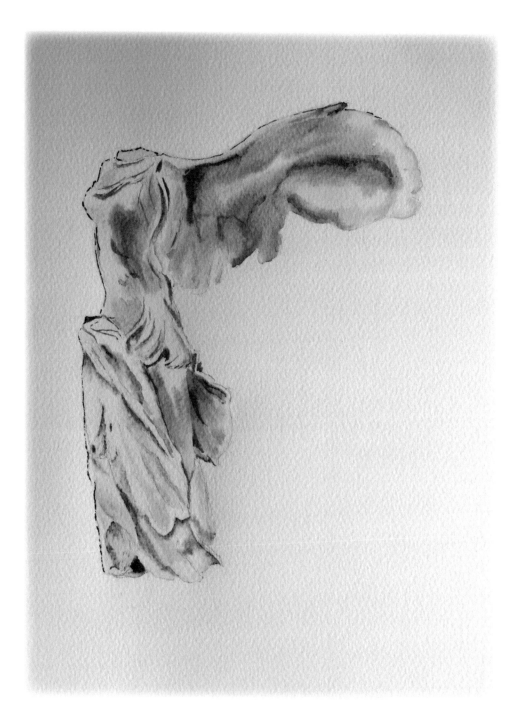

Winged Victory of Samothrace

I am Nike,
muscles flexing, wings powered
in victory shout,
enchanted in ancient white marble,
smooth in flowering robes,
draped and flowing in the salt-ripple breeze,
heralding celebration after the fray.

Stockstill, yet
flying forward.
Damaged, faceless, yet
breathing volumes through long millennia.
Flanked by flashing applause
from every shape and colour.
Sister to all who cup their hands
to trumpet out their triumphs,

though the hands might be implicit
and one wing a patched-up replica.

Growing Up

By the rapids,
at the end of the holidays,
you strip off
layers on the grass,
like the years rushing past.
Instinctively I stoop
to scoop up after you.
You scamper down the bank
too steep for me to follow now,
stiff unbending legs
straight like the river.
The raft fills up
as you take your place,
waving, with that bright smile
you've had since
I held you to my neck,
tiny and smelling of fresh bread.
Gone are the days I would
boldly go first
to encourage your daring
adventure into girlhood.
I feel the wind rising,
so I entrust you
to unworn paths
that I will never tread,
either before
or behind you.

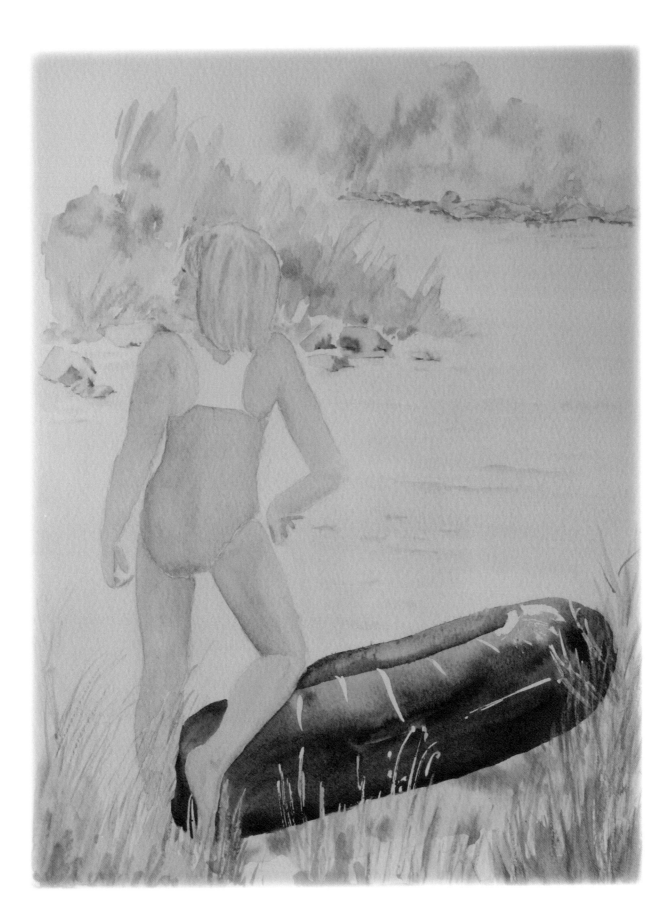

A Tearful Limp

Mending now with just a limp to show
that death clawed wildly at my door last year.
Memories flood in and tears, they come and go:

that hole drilled through my ankle starts the flow,
nailed tight with weighted traction, bloodied smear.
Mending now with just a limp to show

the brutal force of that bone-splintering blow,
snapped exposure to daylight's wincing sneer,
memories flood in and tears. They come and go,

visitors shocked and quiet, on tiptoe,
life-breathing words that fill my heart with cheer.
Mending now with just a limp to show.

Priorities changed, this crash enforced a 'No'
to family adventures planned for the end of each year.
Memories flood in and tears, they come and go.

Muscles withered like wizened grapes. A slow
de-tailed lizard on the wall appears.
Mending now with just a limp to show.
Memories flood in and tears, they come and go.

A Survivor

You don't need your roots hidden underground
to be beautiful,
picture pretty of perseverance.
Your delicate yellow star
fans into petite pink petals
and your roots of durable strength,
intentionally visible,
resilient,
show how you survive.

The Journey

So I'm not afraid of now:
the ruts in the road
and what's round the corner,
my ungainly femurs, stiff and robotic,
the slowed down pace,
stubborn fists in my face,
piercing shards cutting in,
the weighty shoulder load.

I'm pressing forward,
grabbing with a firm grip,
stepping up, sweating,
lungs ballooning
as I follow veterans' stories,
who've ploughed through even worse terrain,
blazing the way,
cheering me on,
pulsing adrenaline into my veins.

Head back
flint set,
eyes on what's to come,
a full-bodied hope.

About the Author

A Kenyan childhood, a girls' boarding school in England, a Welsh degree in English Literature and Linguistics and teacher training in central London, Helen Freeman continues to travel and write wherever she goes. She has taught in East Africa, UK and since 2001, in the Sultanate of Oman, where she currently lives with her husband and two children. She has a great interest in poetry, languages and cross-cultural living. On May 18th 2009, she was involved in a life-threatening road traffic accident in Muscat and underwent several difficult operations whilst in intensive care. During rehabilitation, she decided to document her experiences, her visitors and her surroundings in poetry. email: angus_helen@yahoo.com

About the Illustrator

Margaret Jeeves has a lifelong love of art and uses a variety of techniques to create paintings and sketches in watercolour, acrylic, pastel and charcoal. Her subjects cover wildlife, landscapes, life drawings and portraits. Based in London with her family, Margaret has traveled widely, and inspiration for her work comes from many places including Southern Africa, the Middle East and Europe. She has formal qualifications in fashion and design. email:margaretjeeves@btinternet.com.

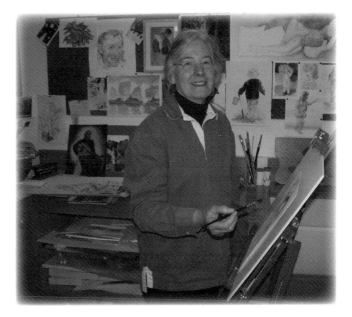

CPSIA information can be obtained
at www.ICGtesting.com

2344LVUK00005BA